COLOR ME CRAZY

COLOR ME CRAZY

INSANELY DETAILED CREATIONS
TO CHALLENGE YOUR SKILLS AND
BLOW YOUR MIND

Peter Deligdisch

A PERIGEE BOOK

PERIGEE

An imprint of Penguin Random House LLC
375 Hudson Street, New York, New York 10014

COLOR ME CRAZY

ISBN: 978-0-399-17527-5

First edition: July 2015

PRINTED IN THE UNITED STATES OF AMERICA

Most Perigee books are available at special quantity discounts for bulk
purchases for sales promotions, premiums, fund-raising, or educational use.
Special books, or book excerpts, can also be created to fit specific needs.
For details, write: SpecialMarkets@penguinrandomhouse.com.

*Dedicated to all the creative people out there:
Whether you've got a roaring inferno, a tiny spark,
or just a dying ember, I hope this book helps fan
and feed that fire within you.*

INSTRUCTIONS

Just add color. In any way you'd like. Don't feel you have to stay between the lines. Unless you want to.

If you are using markers, you might want to put a piece of scrap paper between the pages while you color.

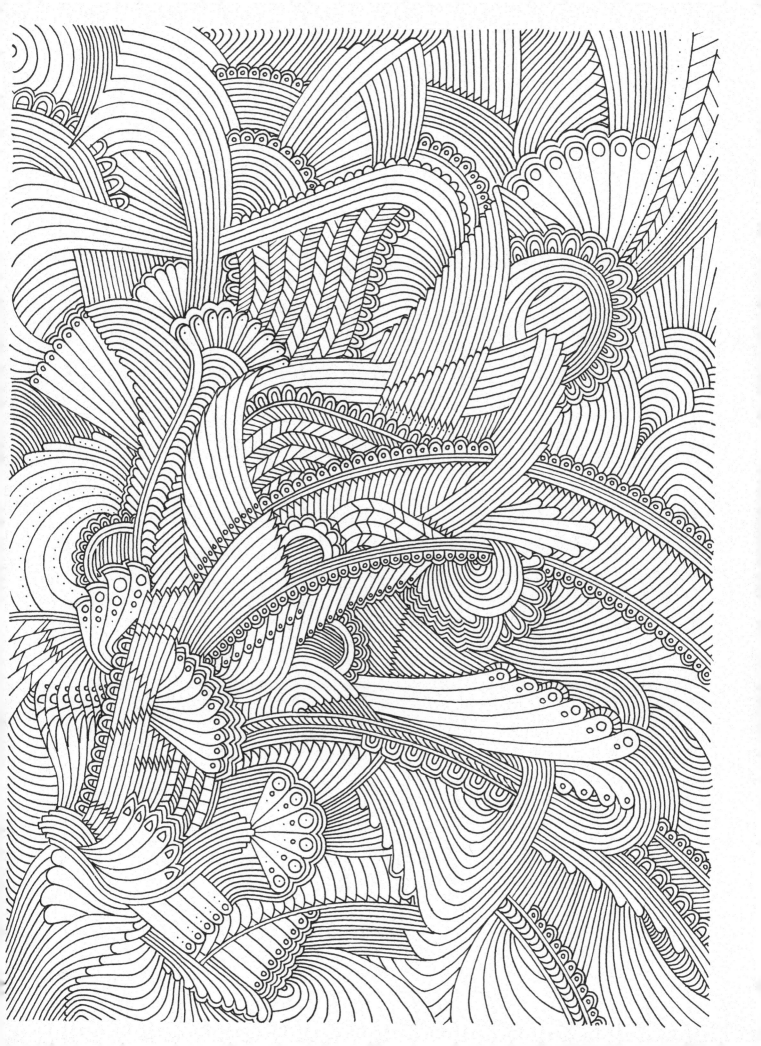

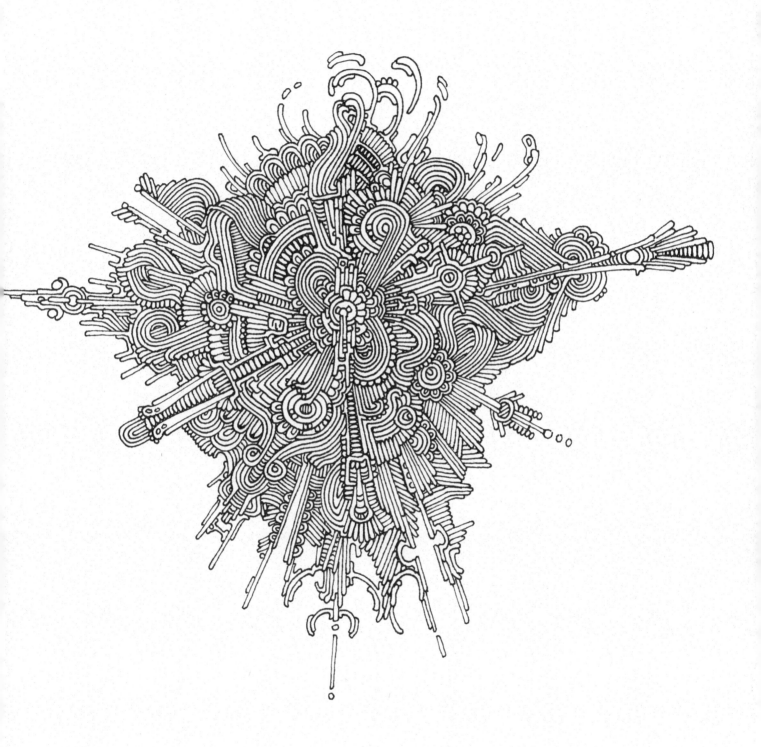

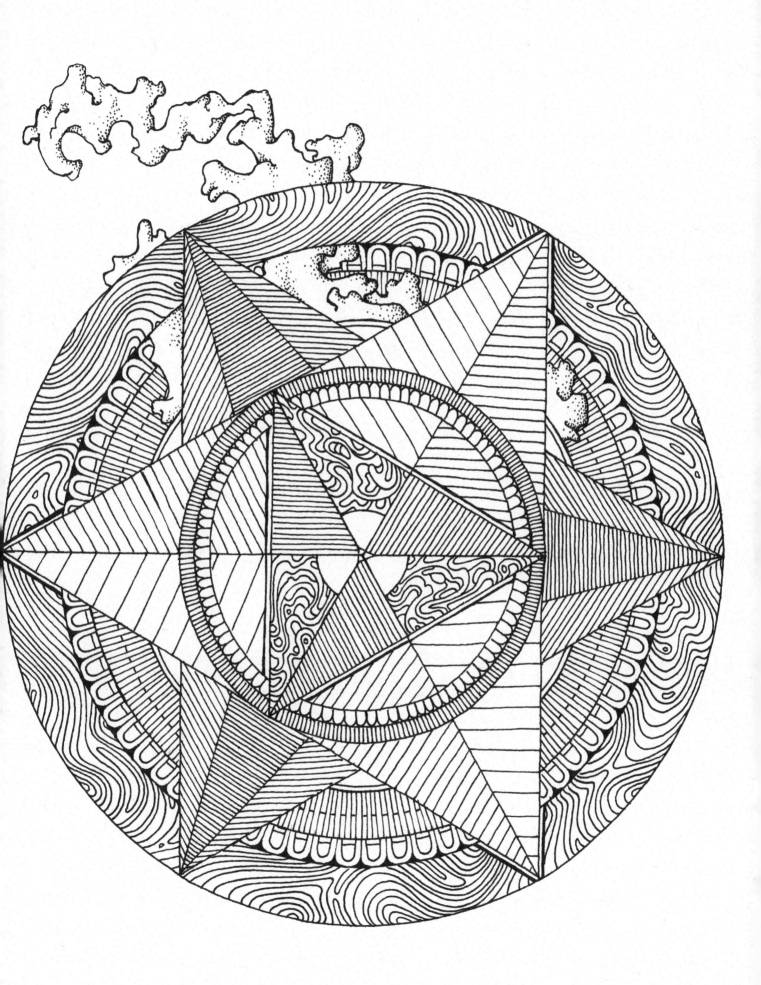

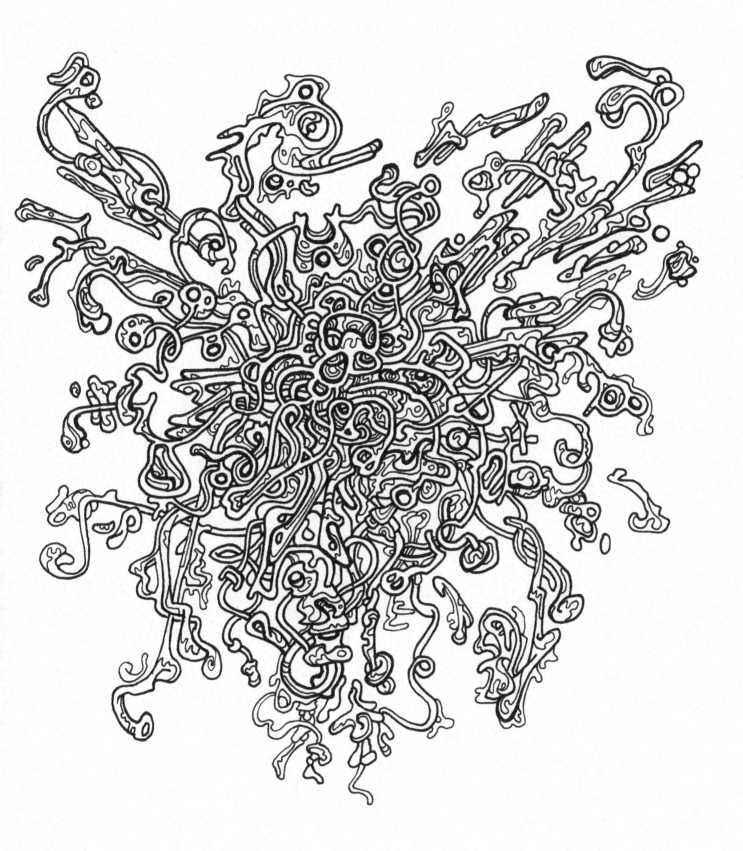

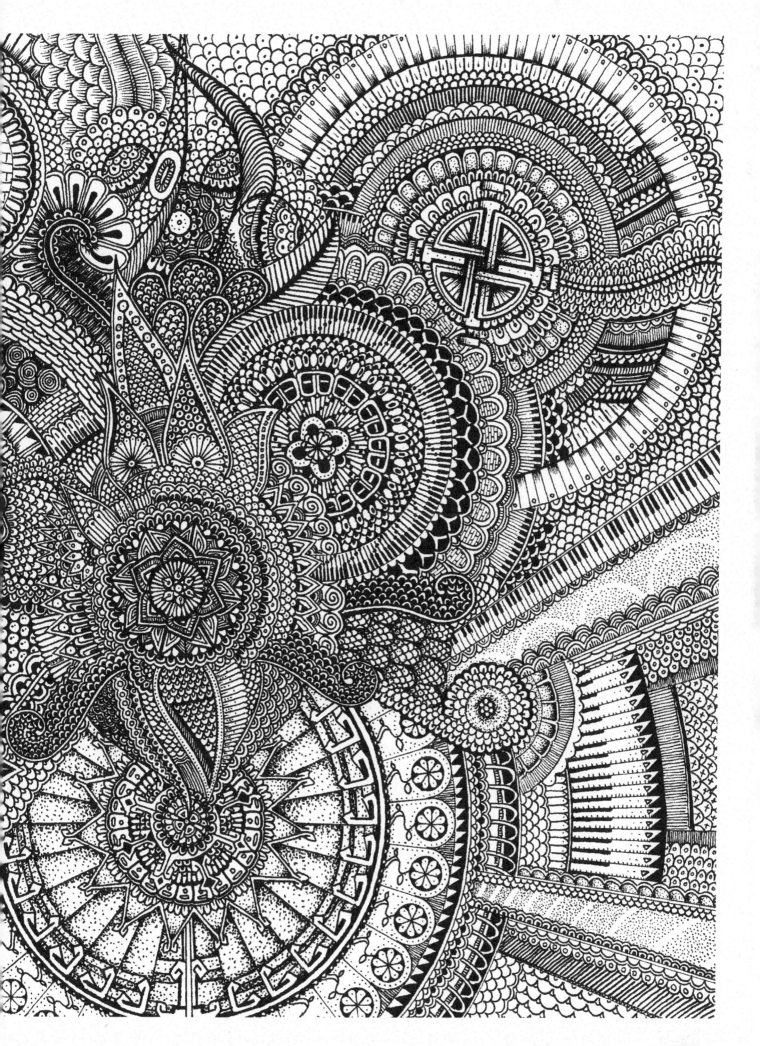

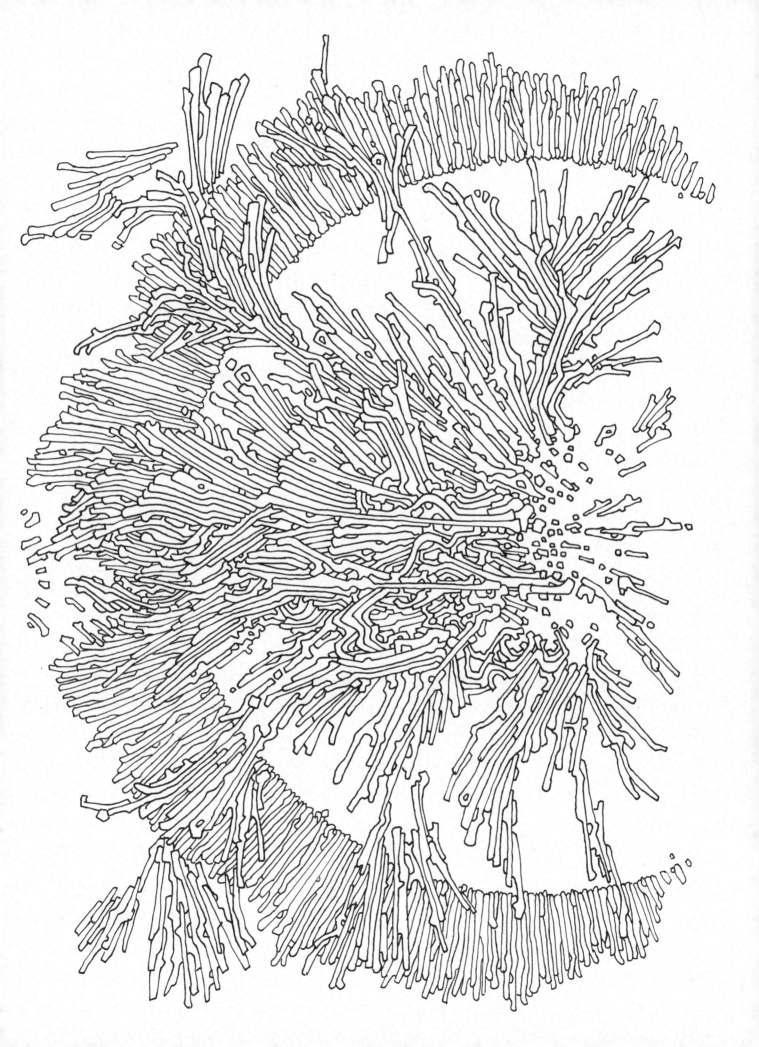

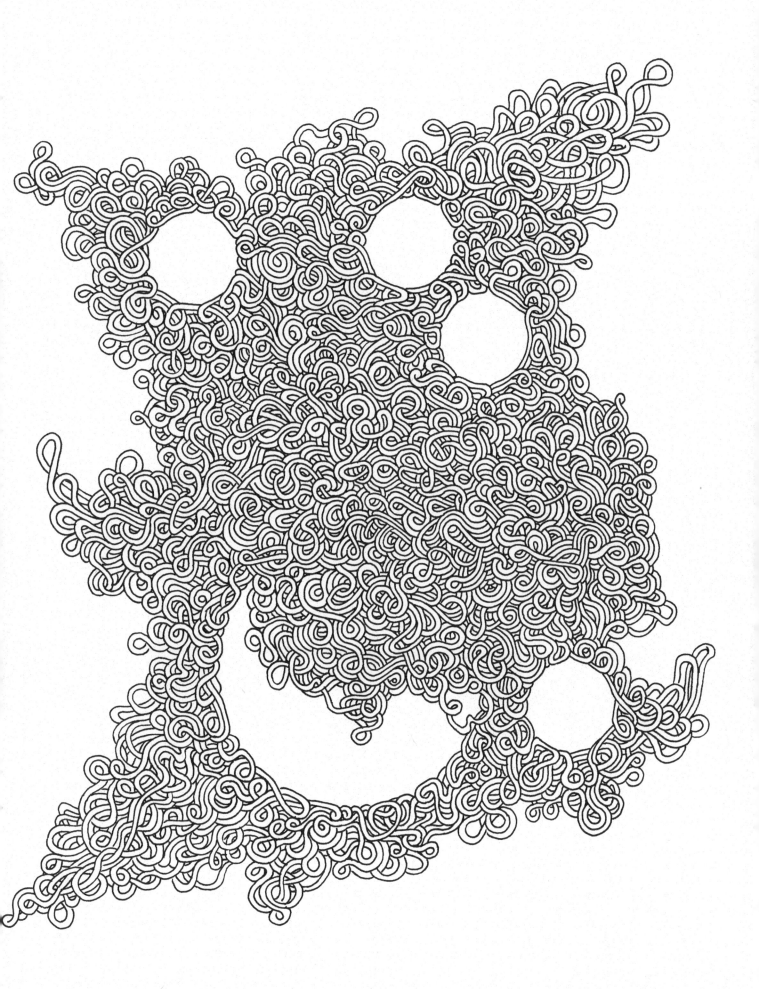

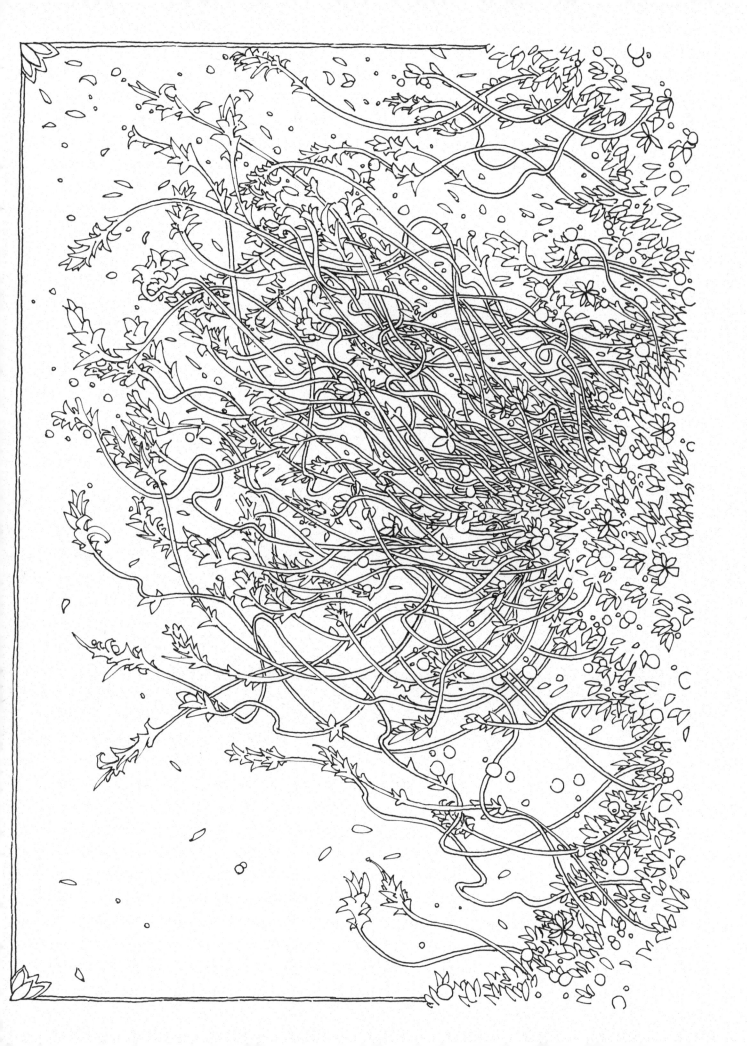

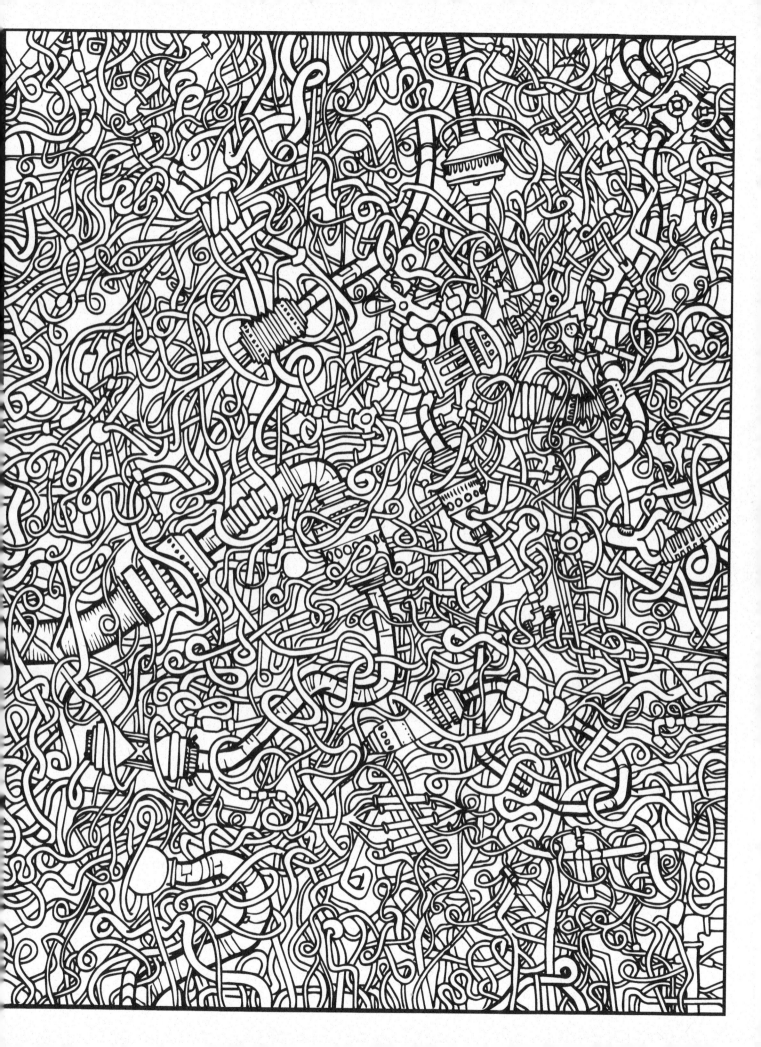

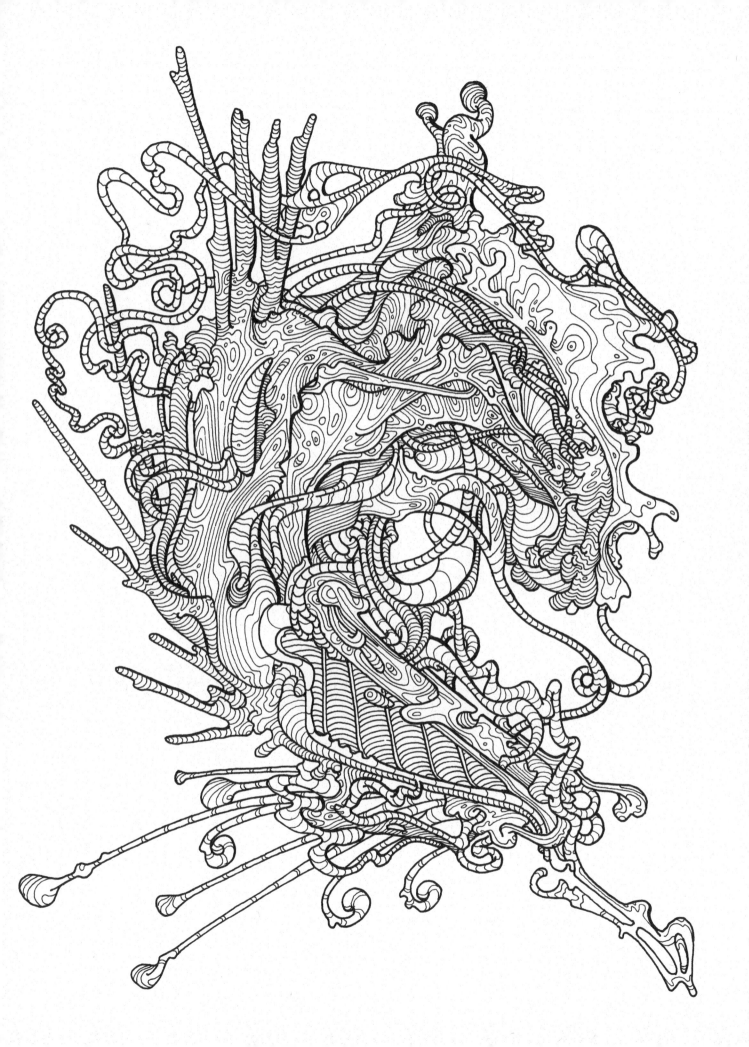

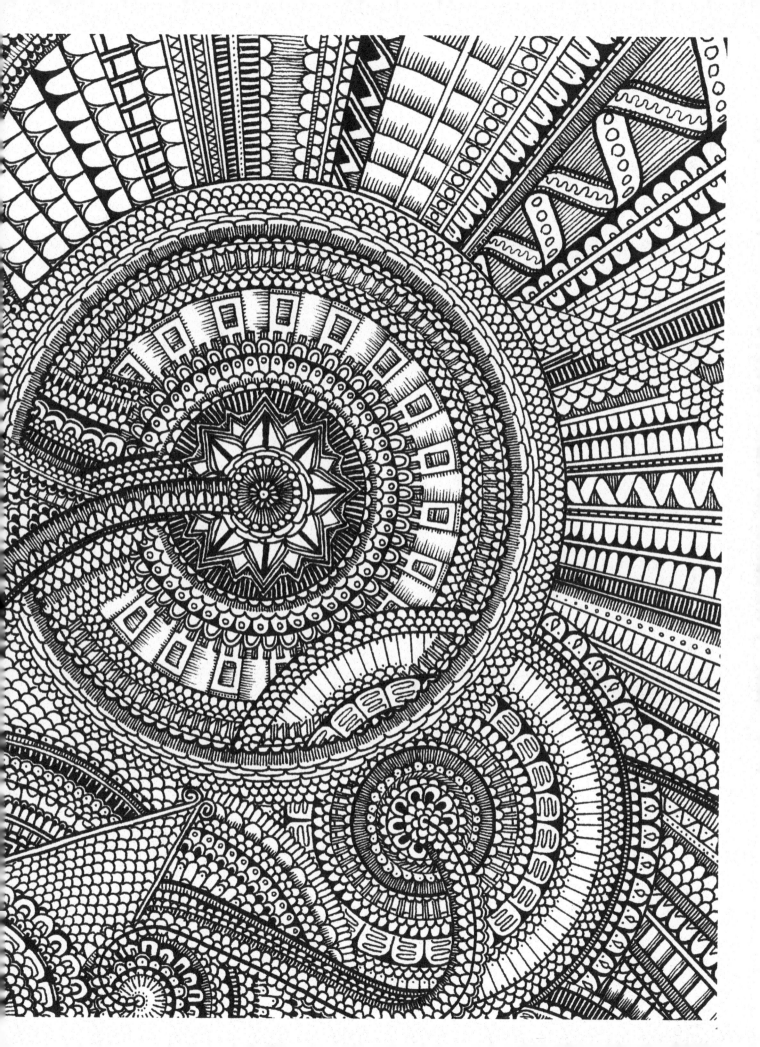

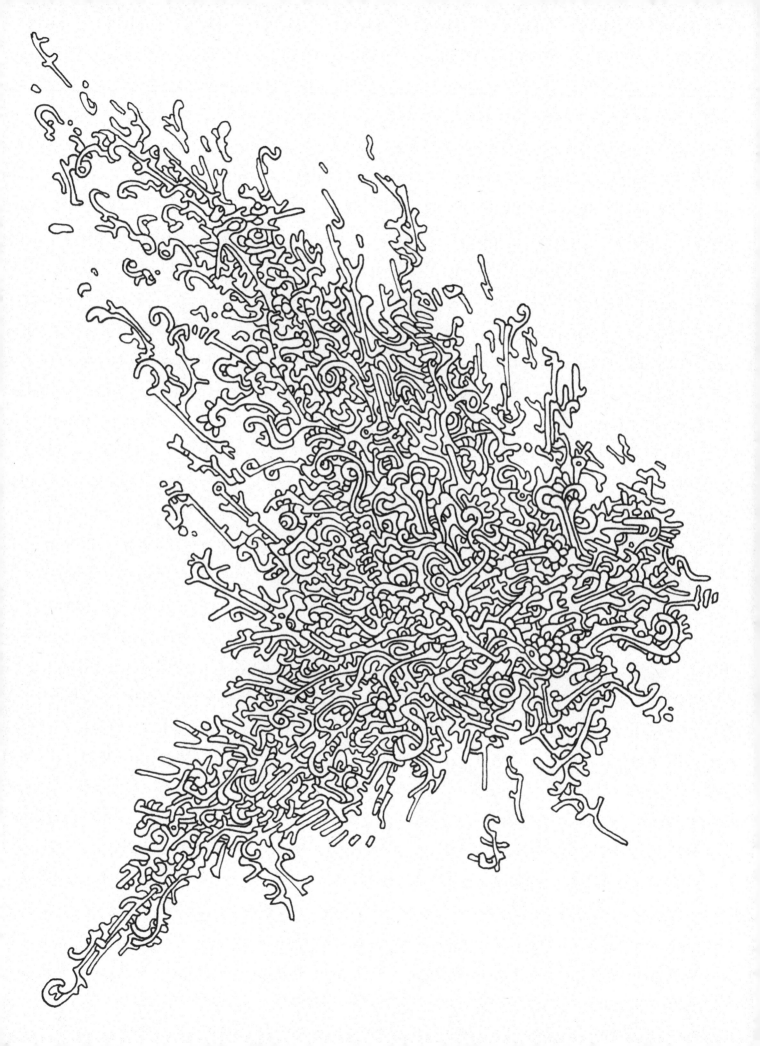

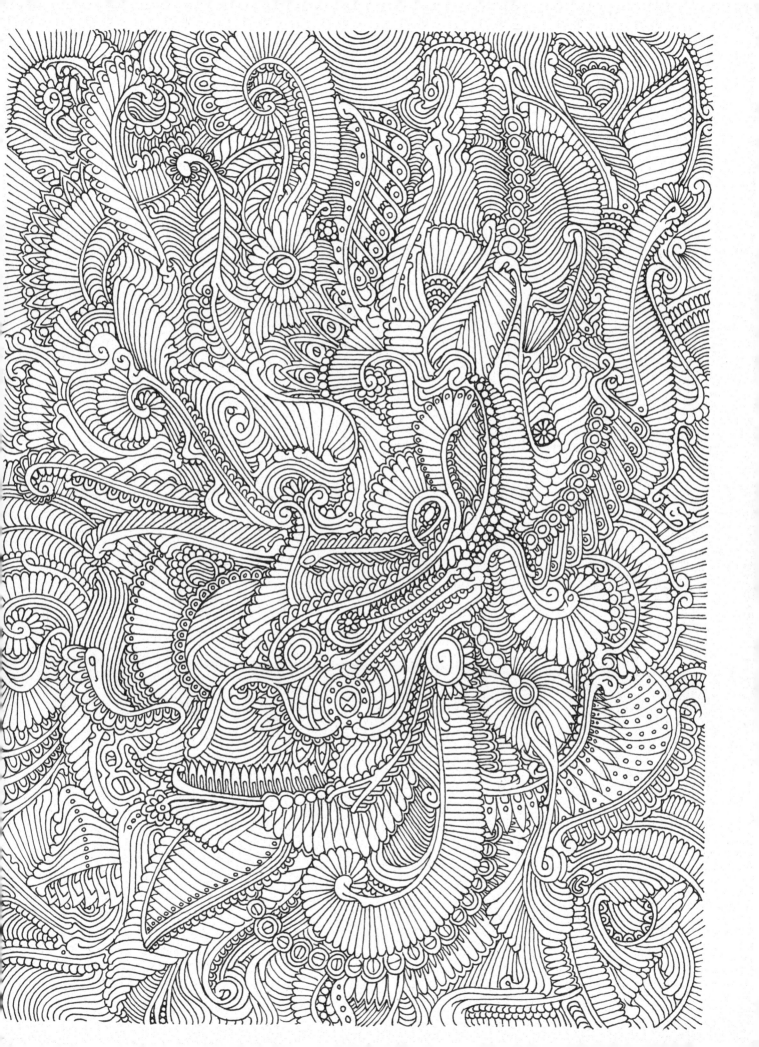

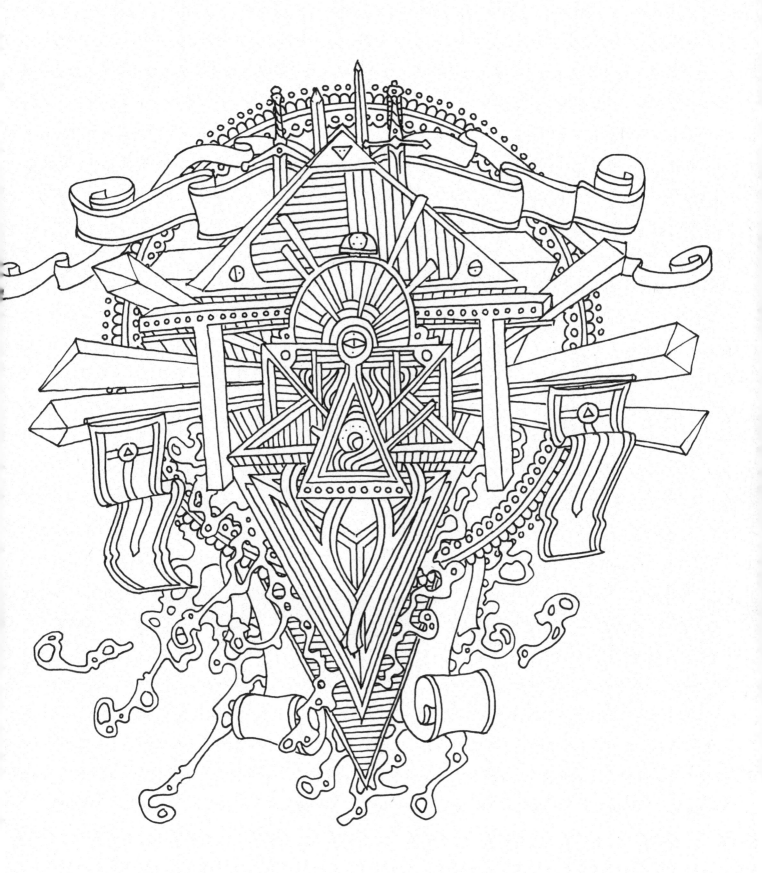

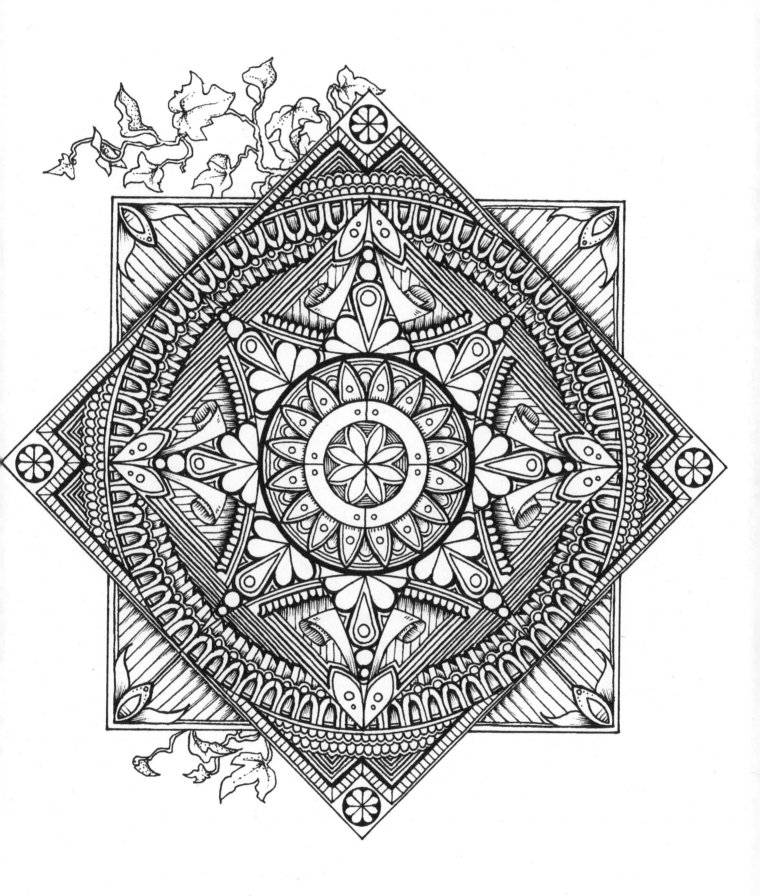

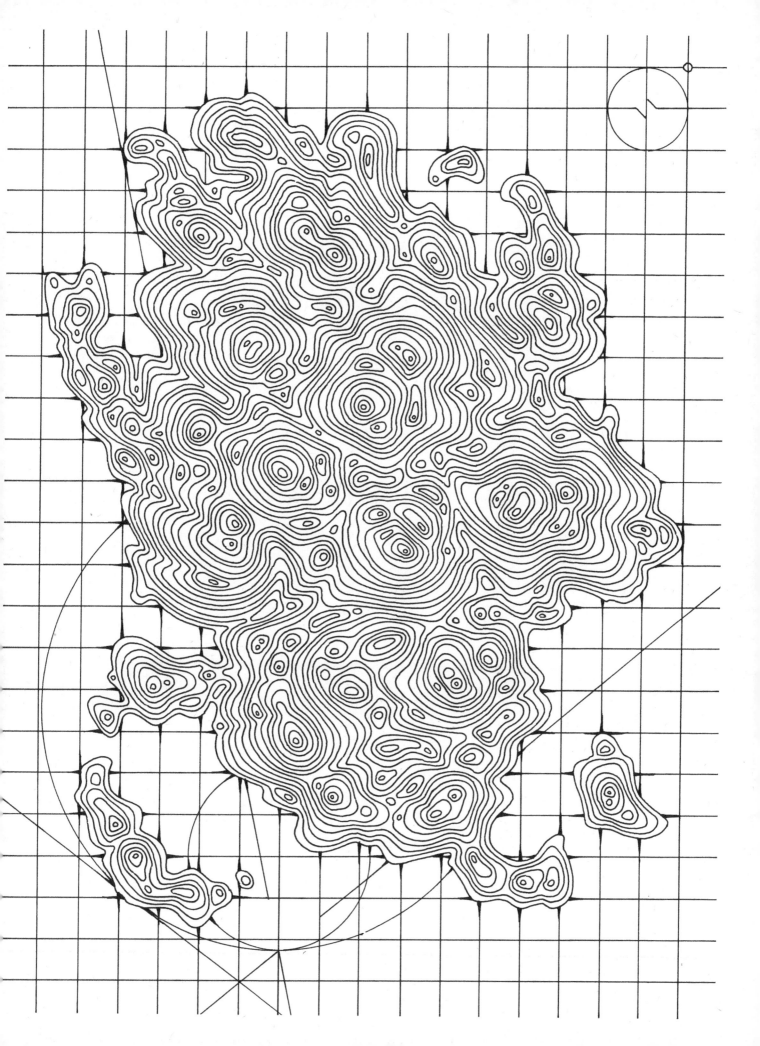

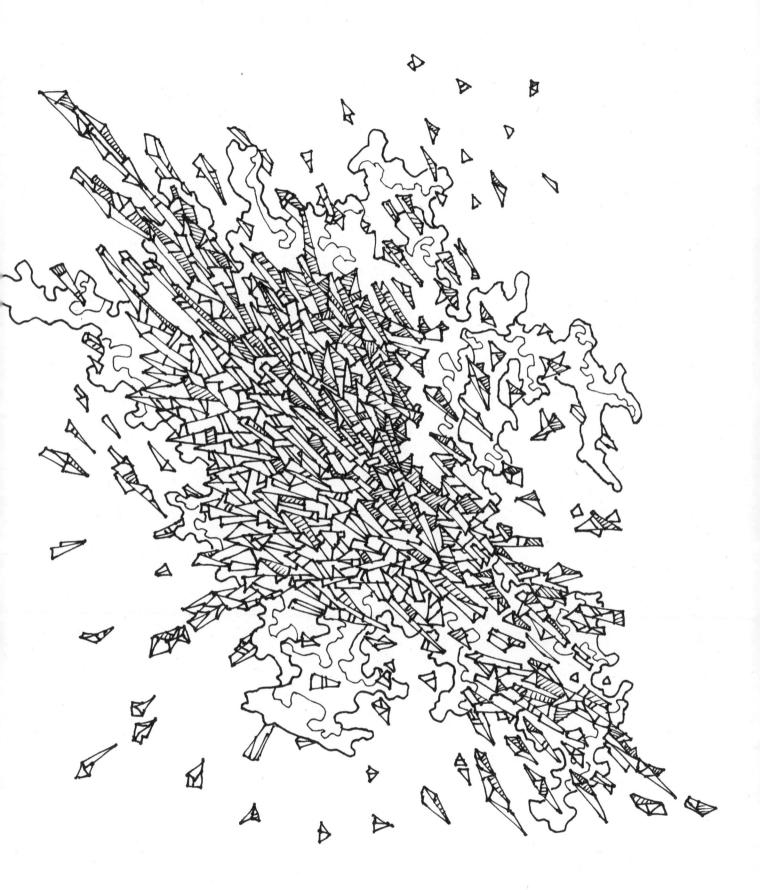

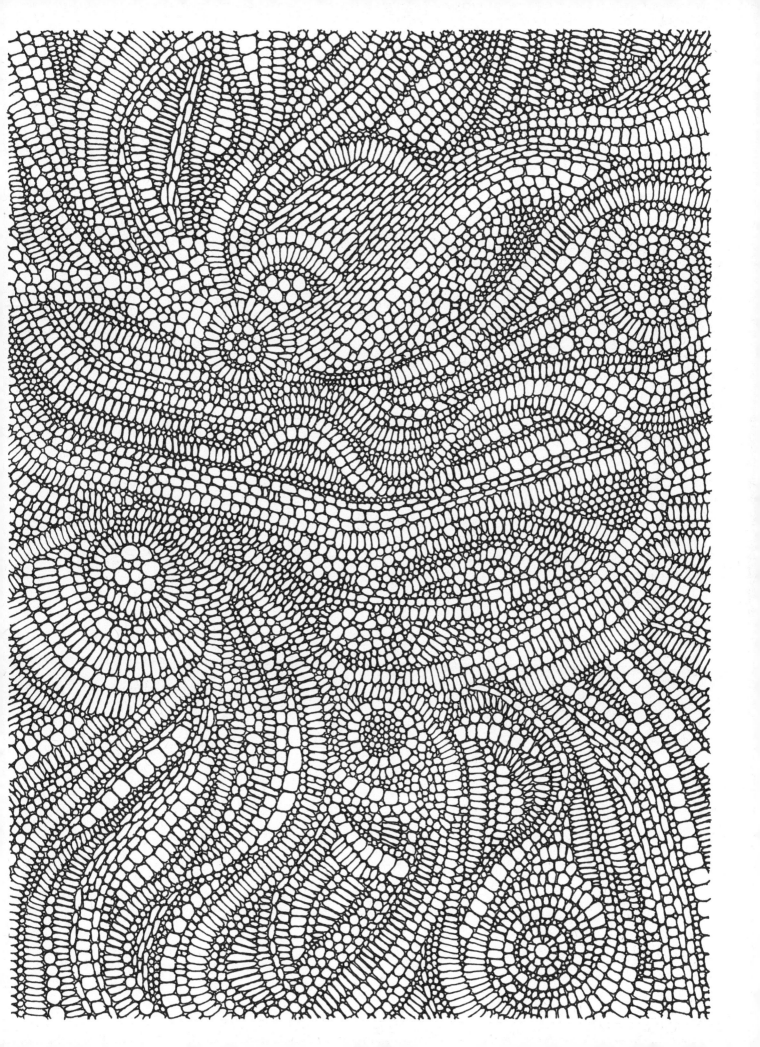

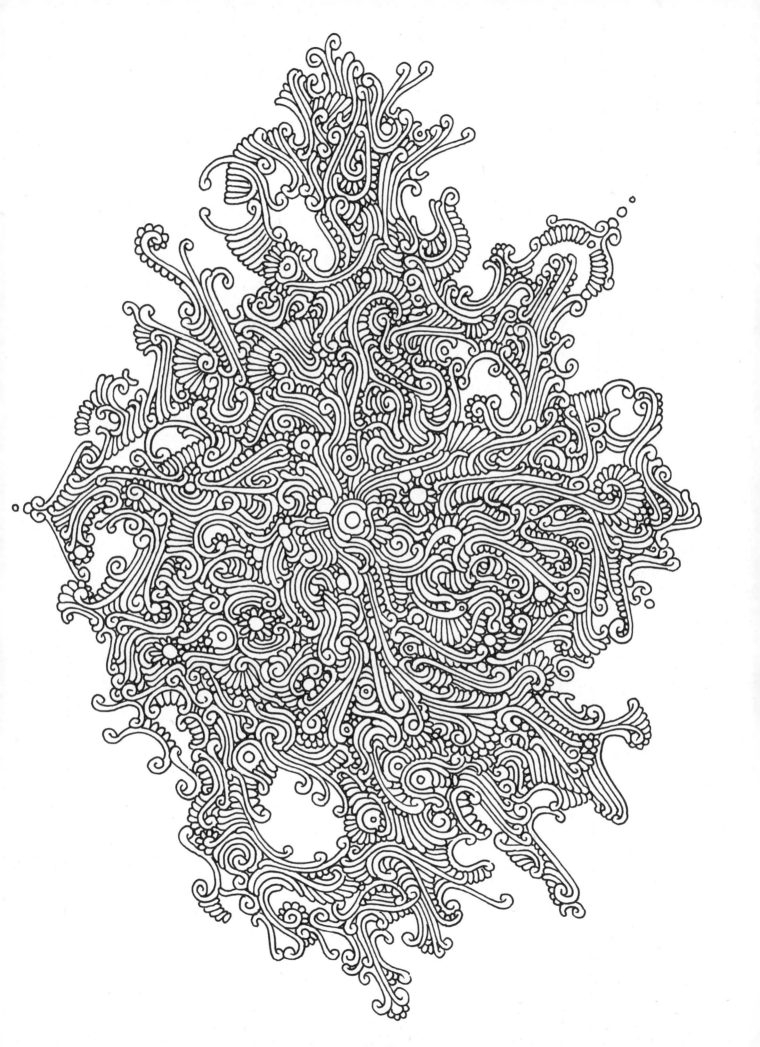

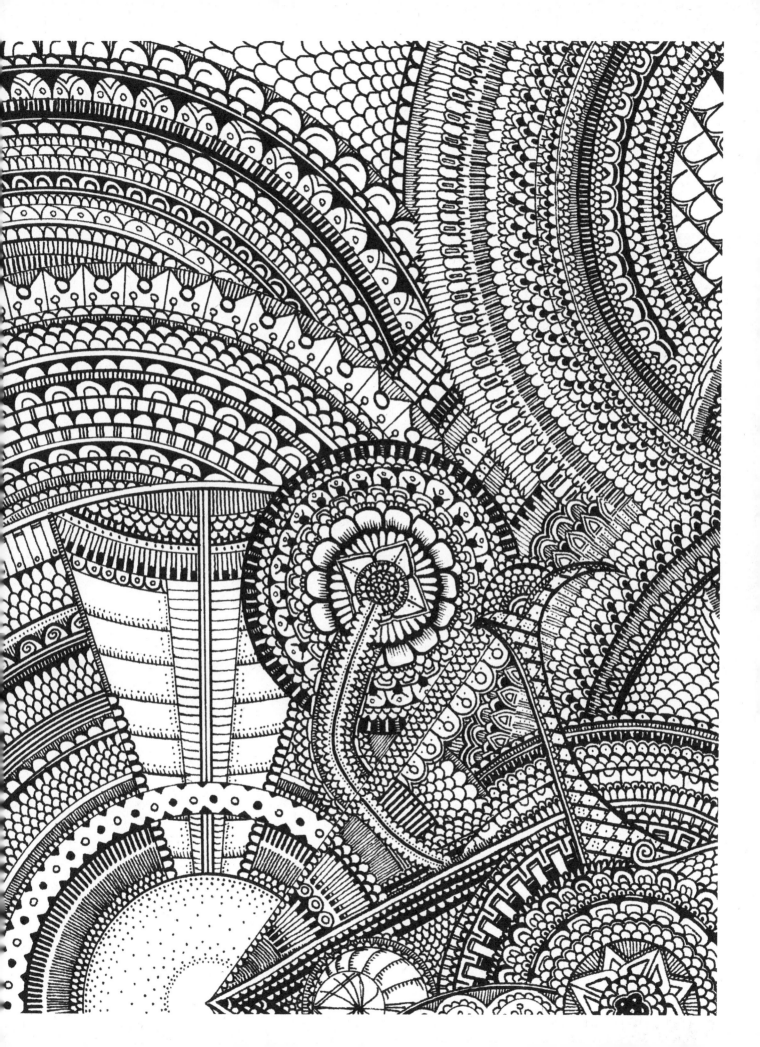

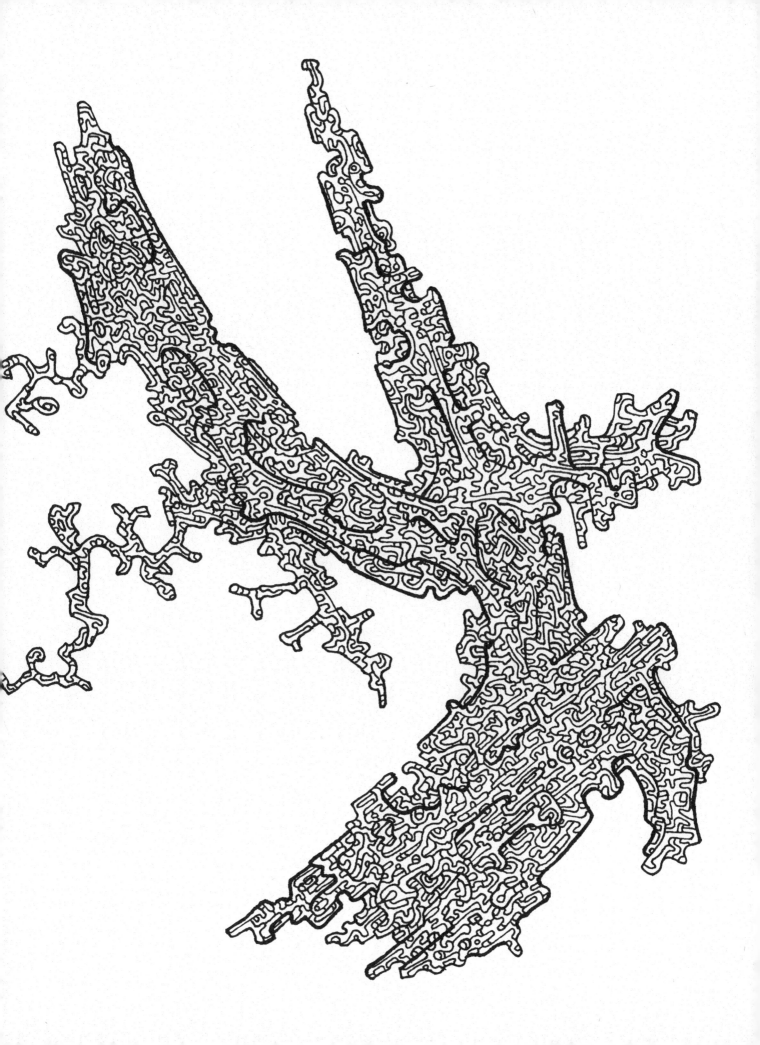

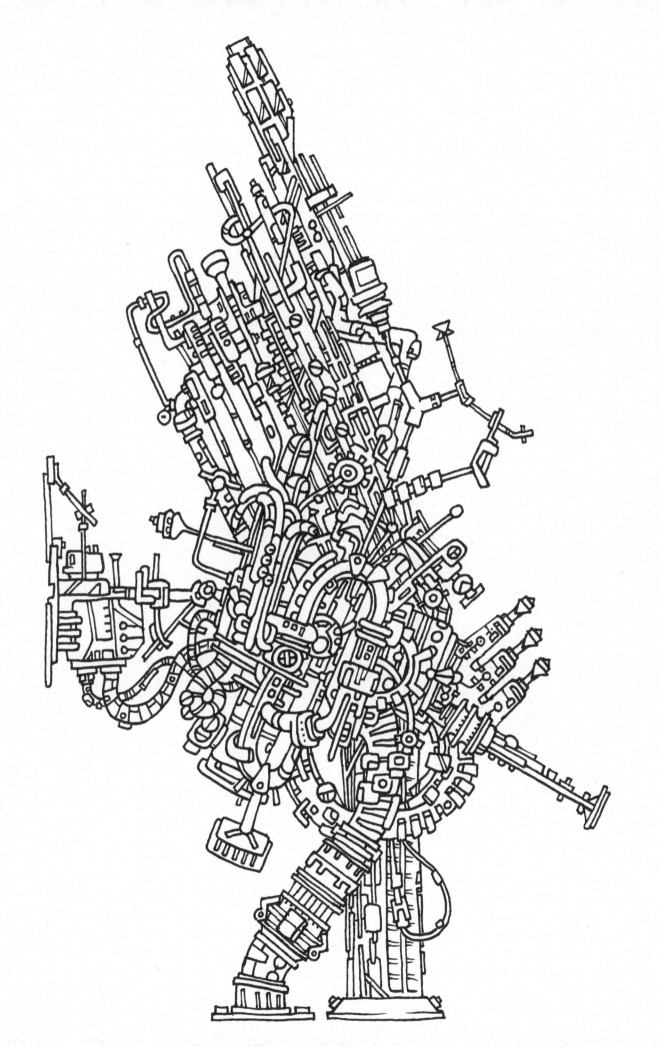

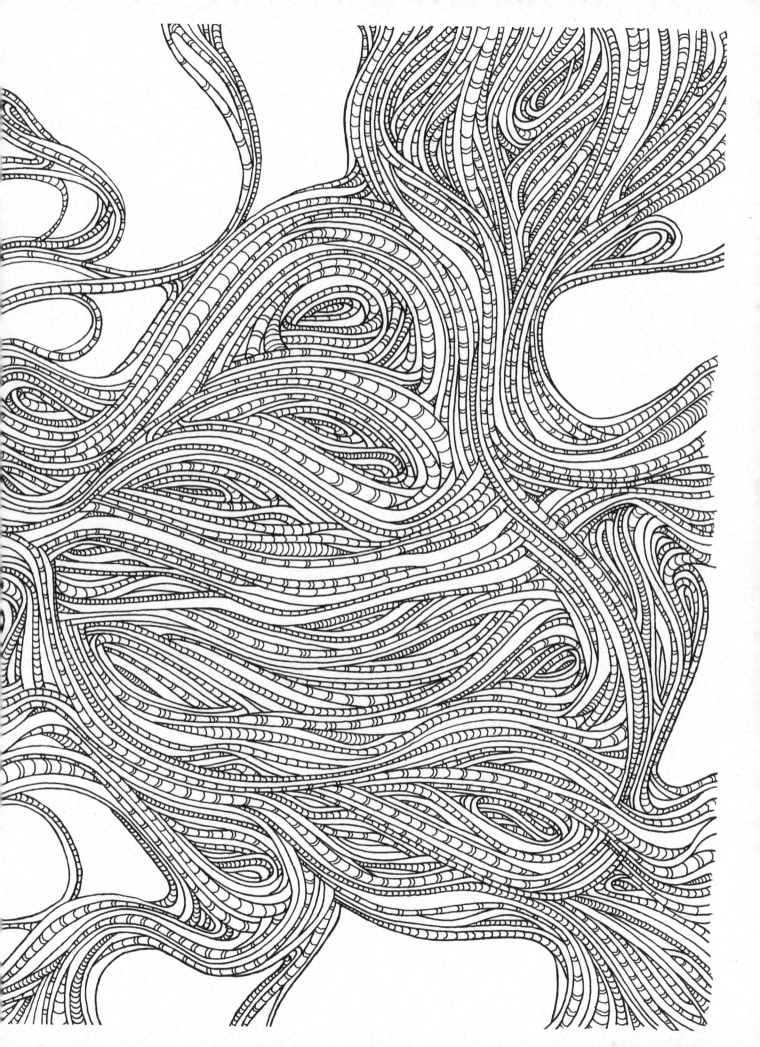

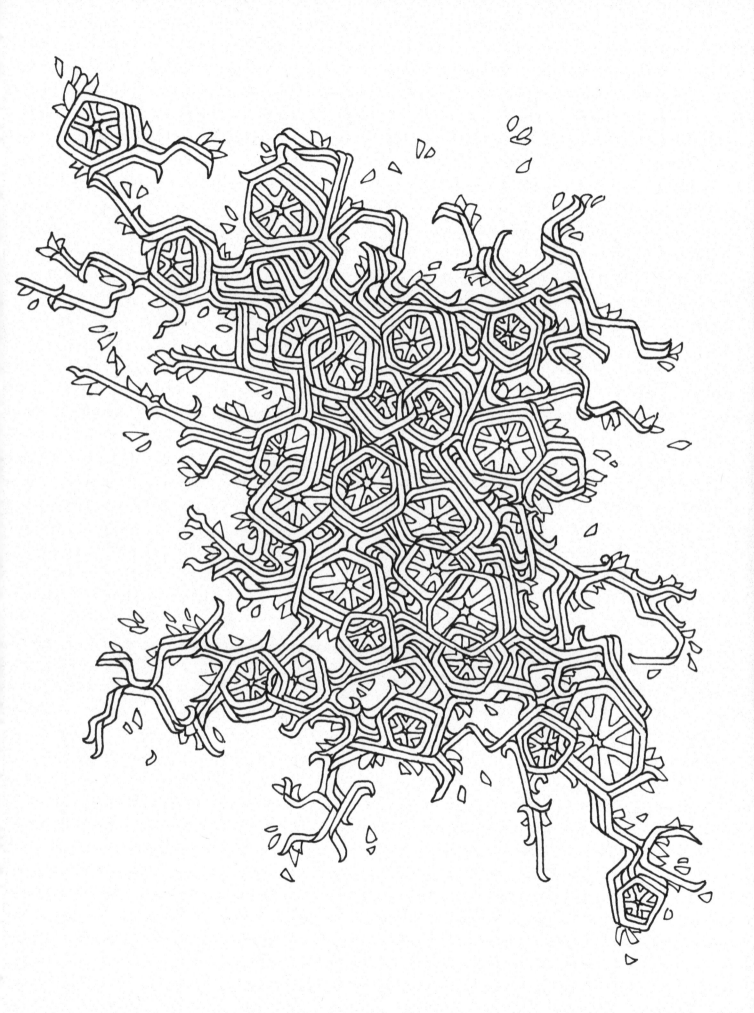

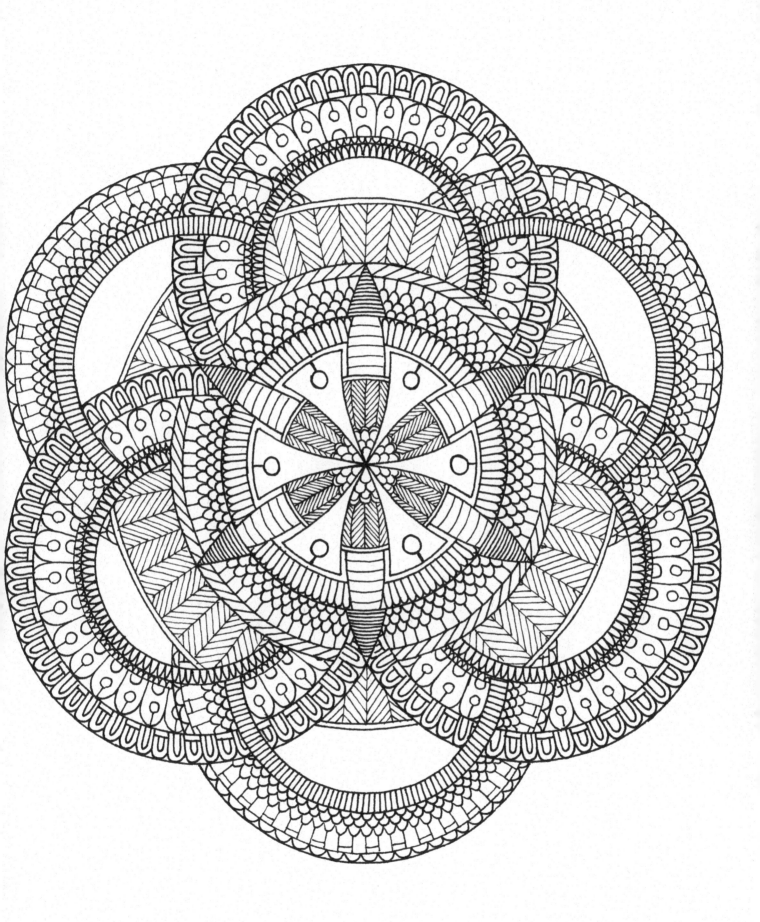

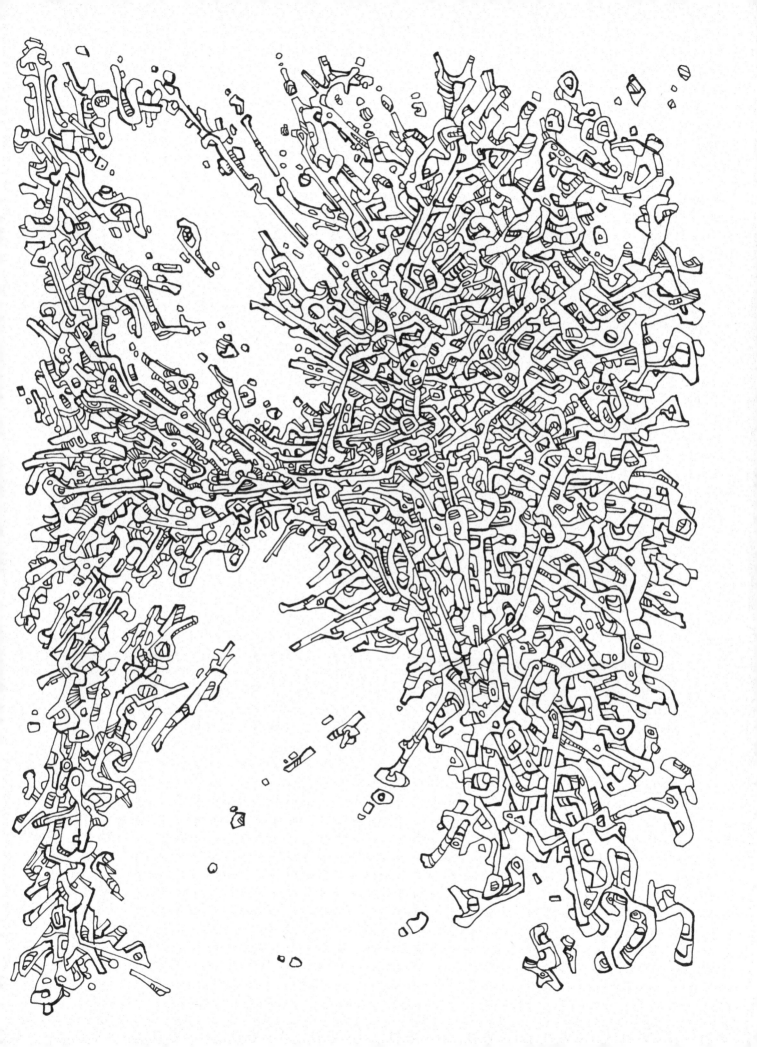

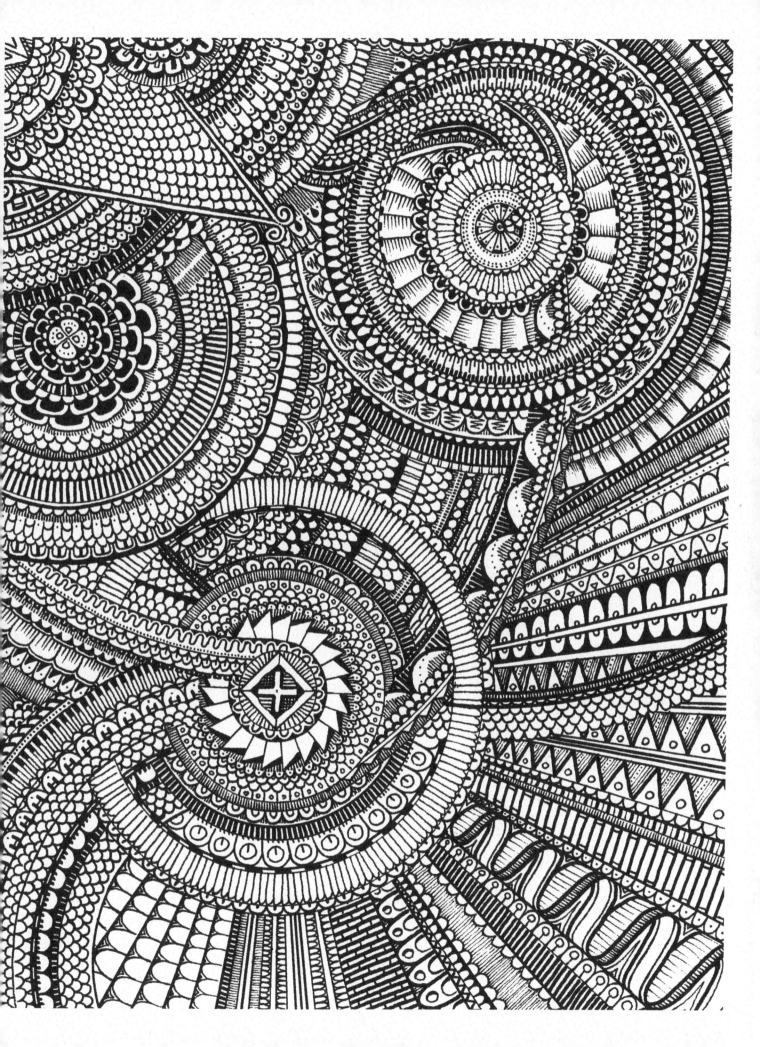

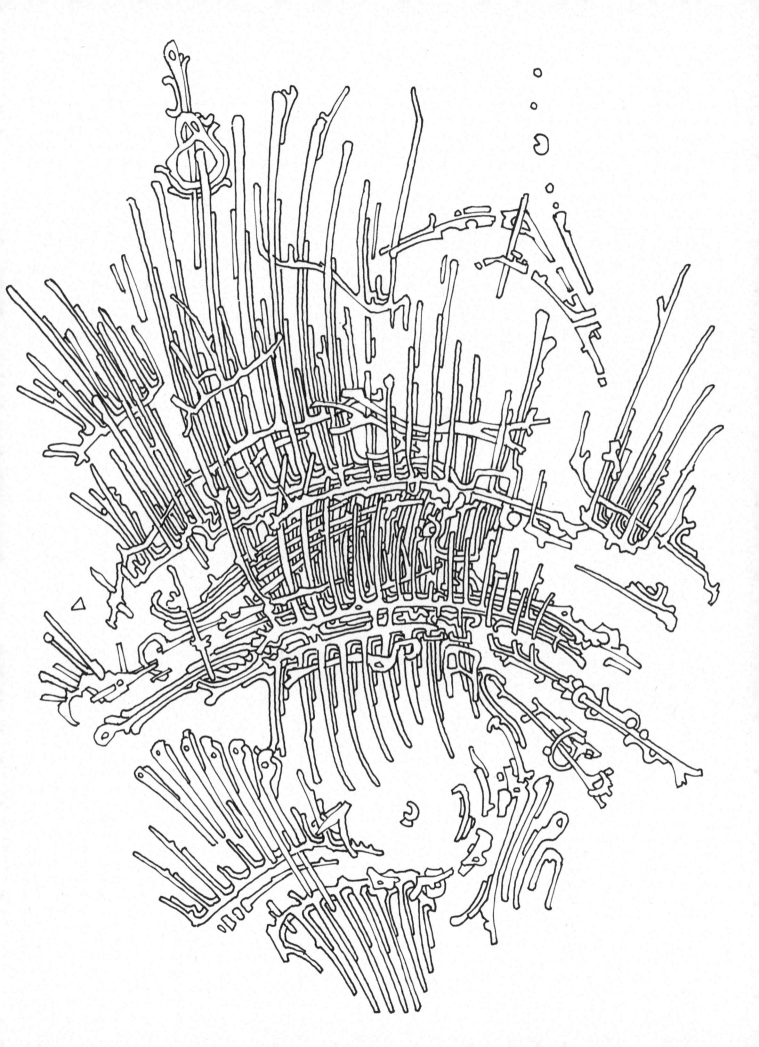

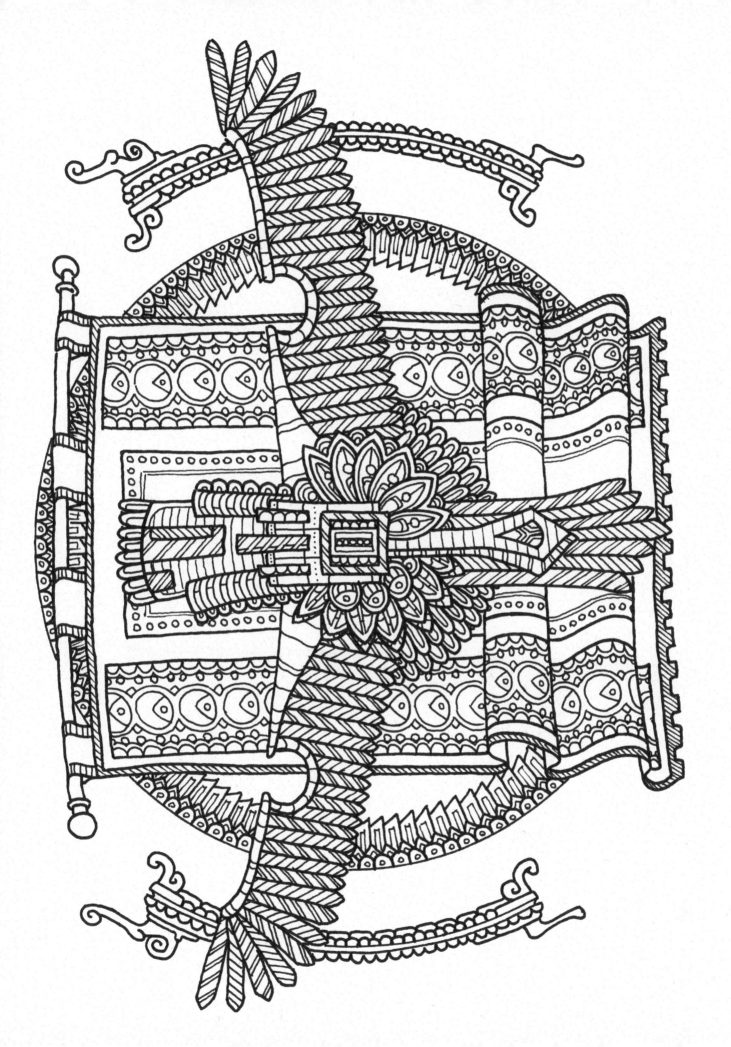

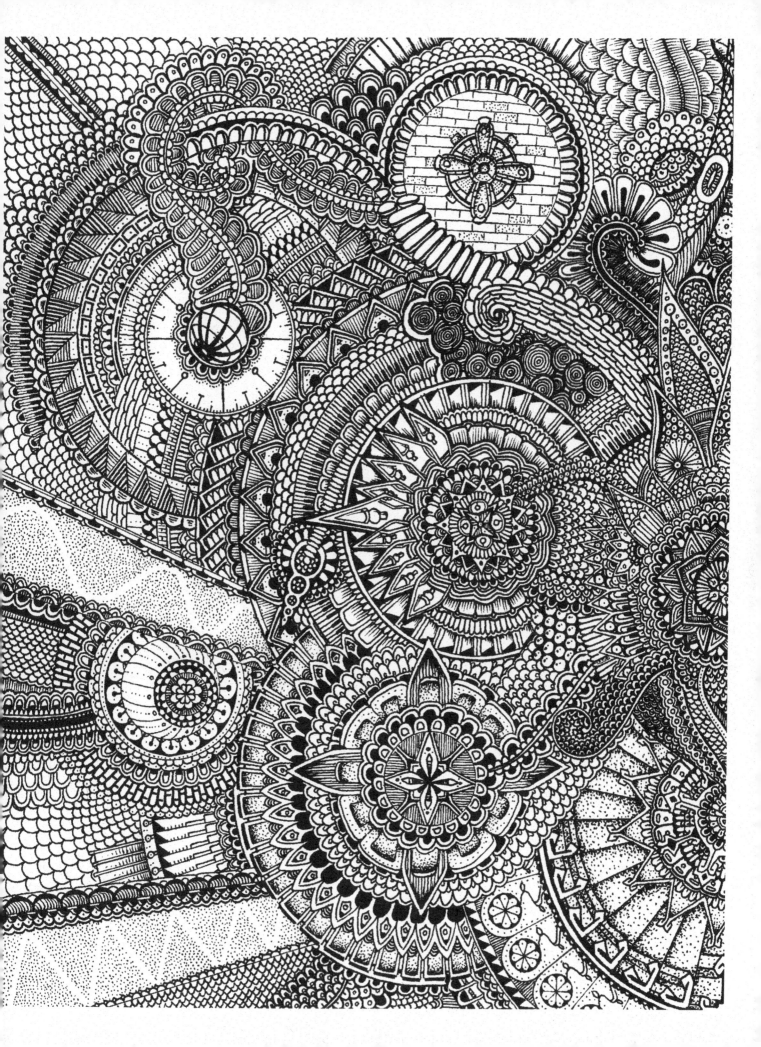

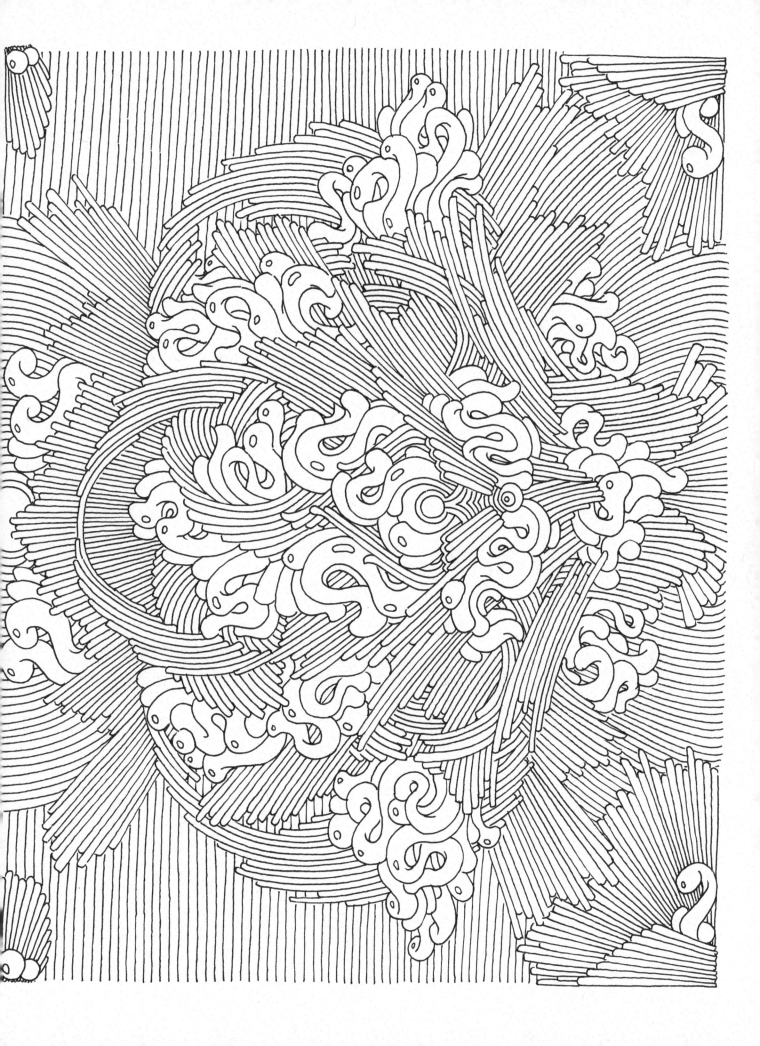

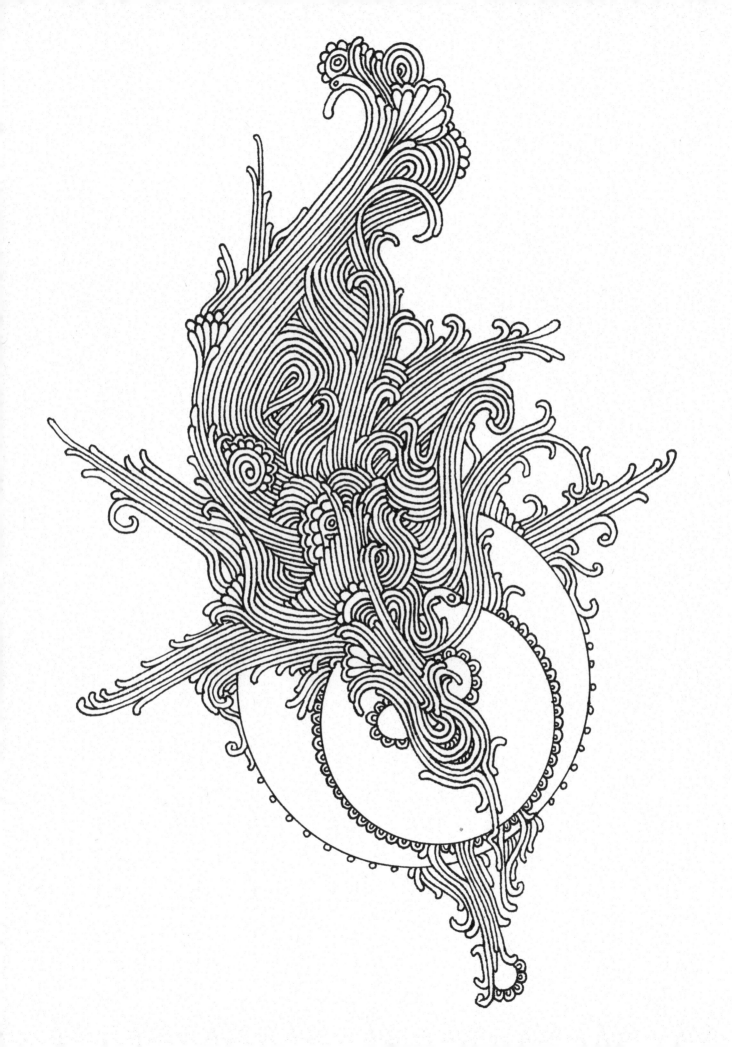

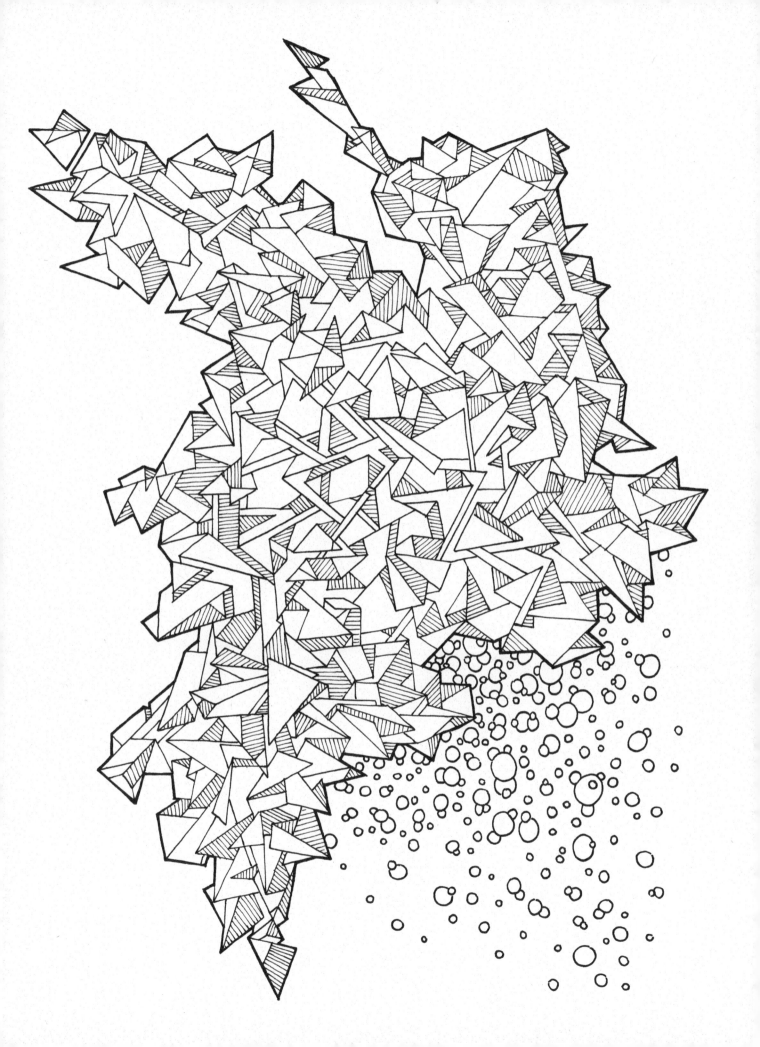

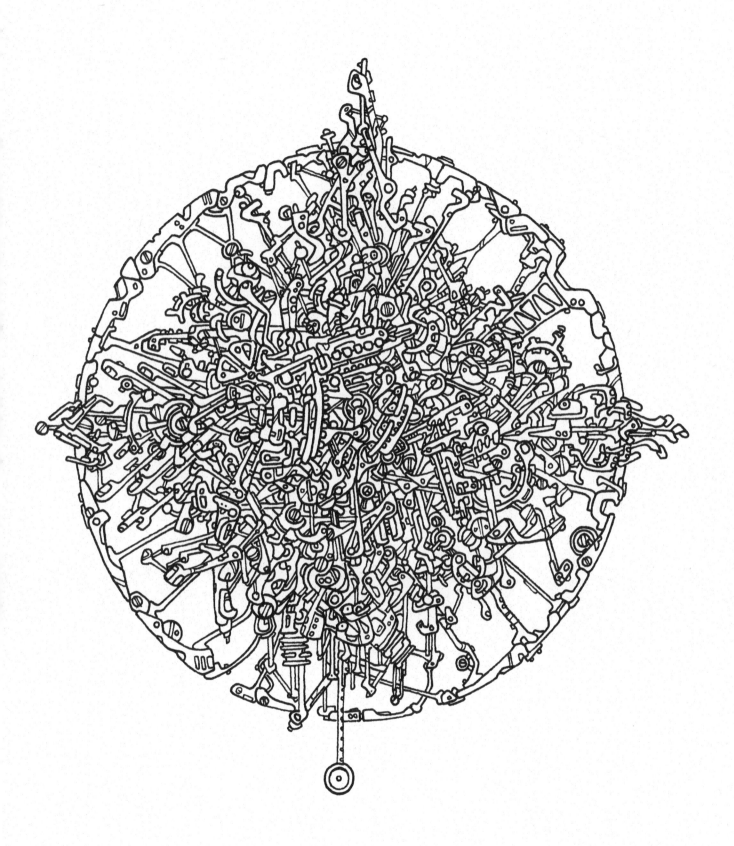

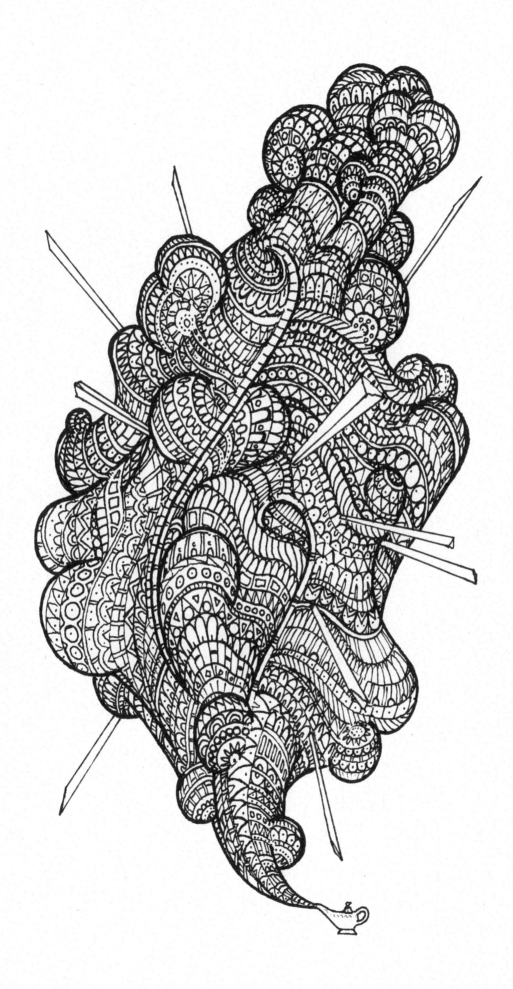

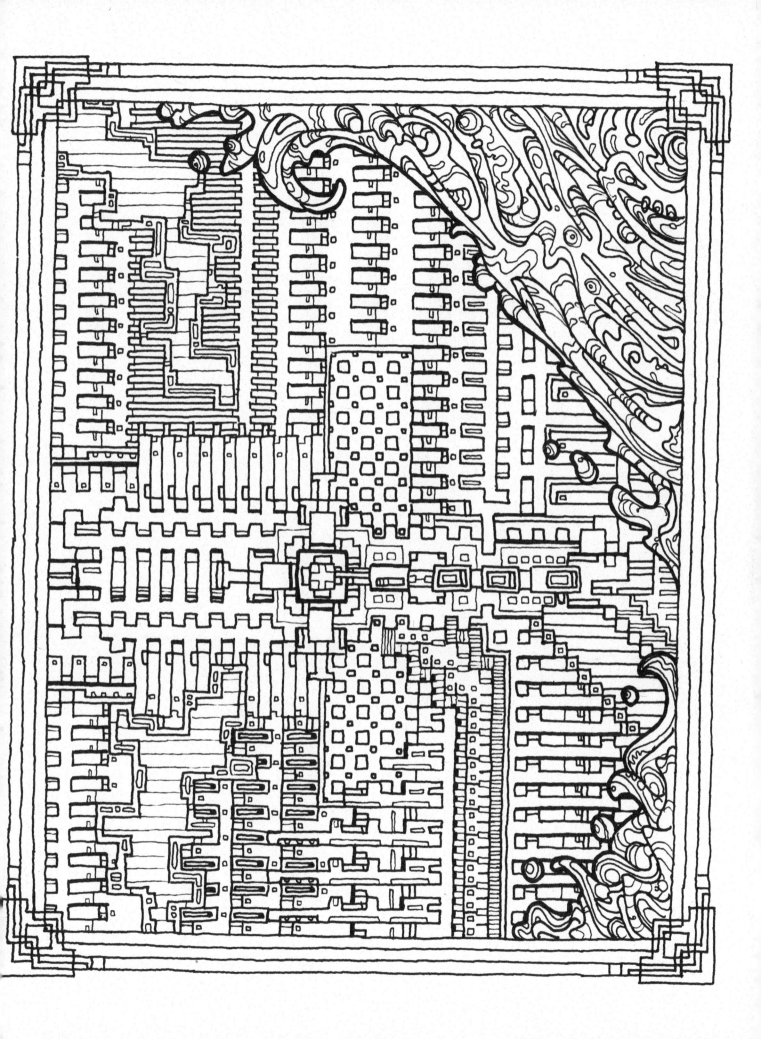

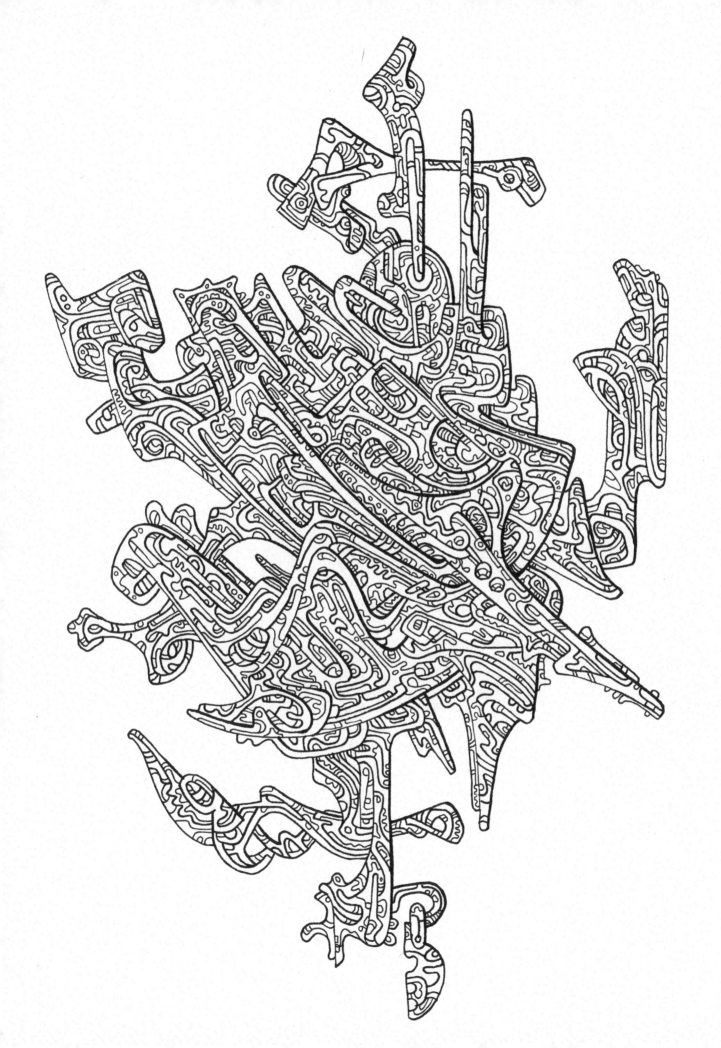

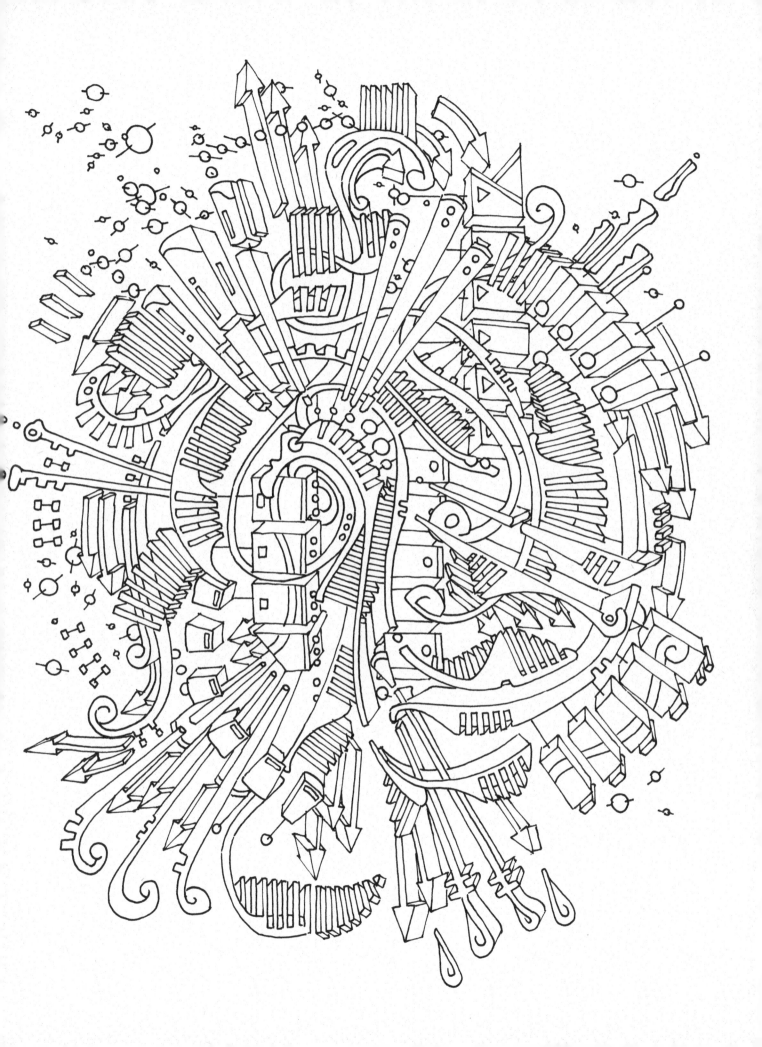

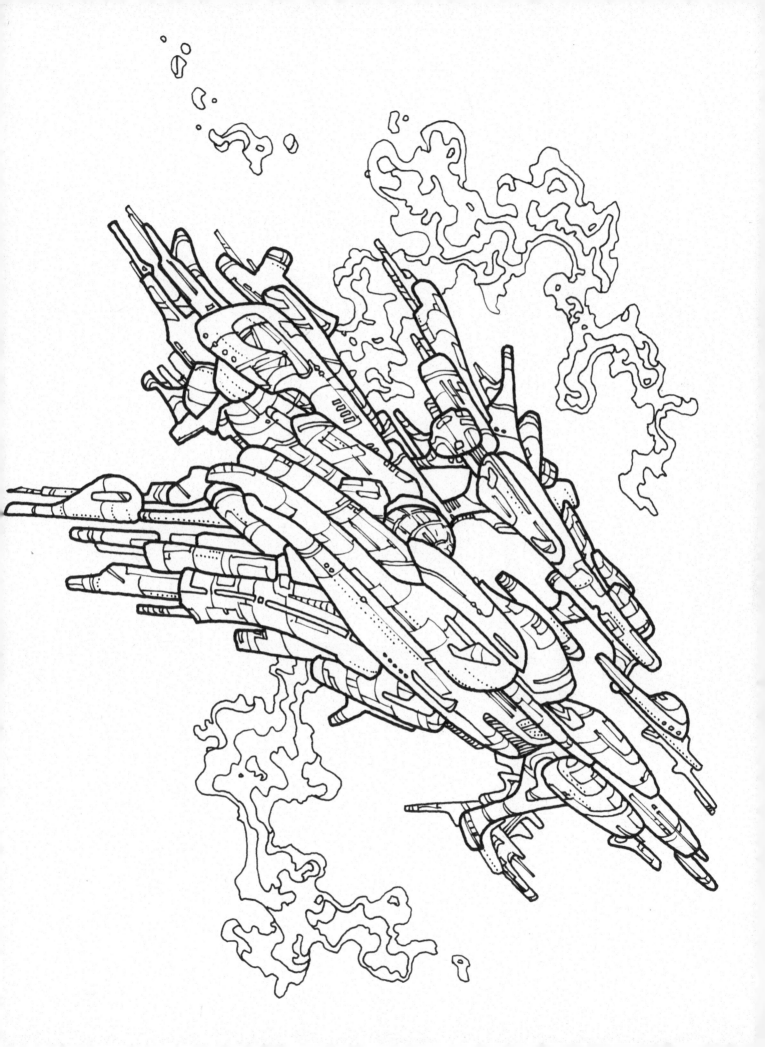

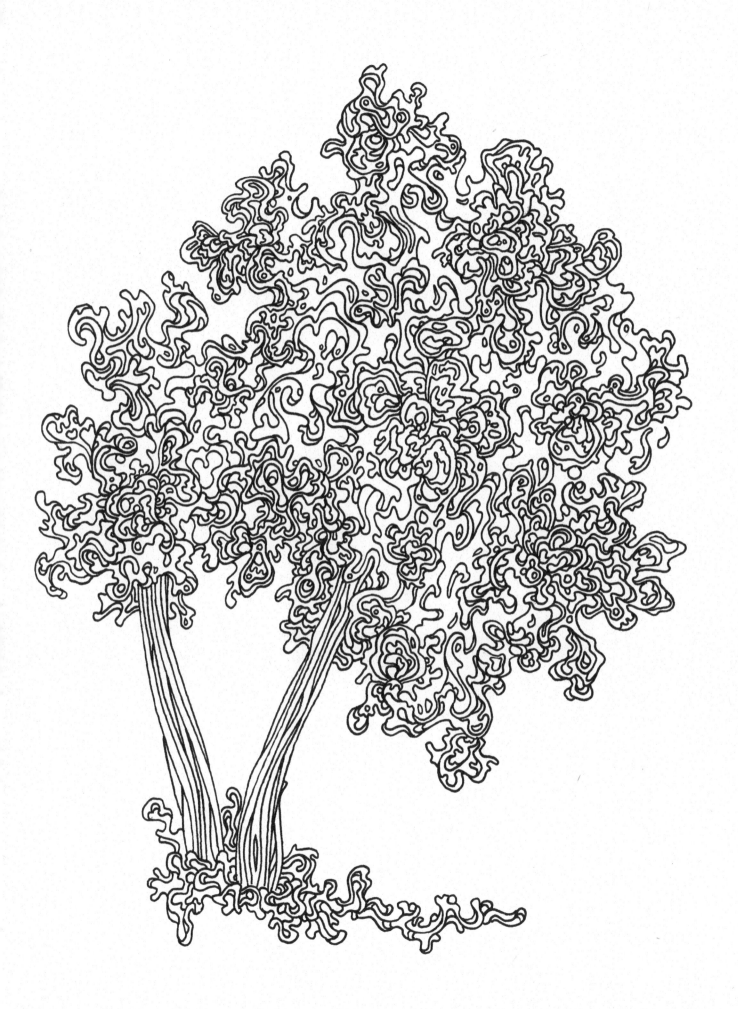

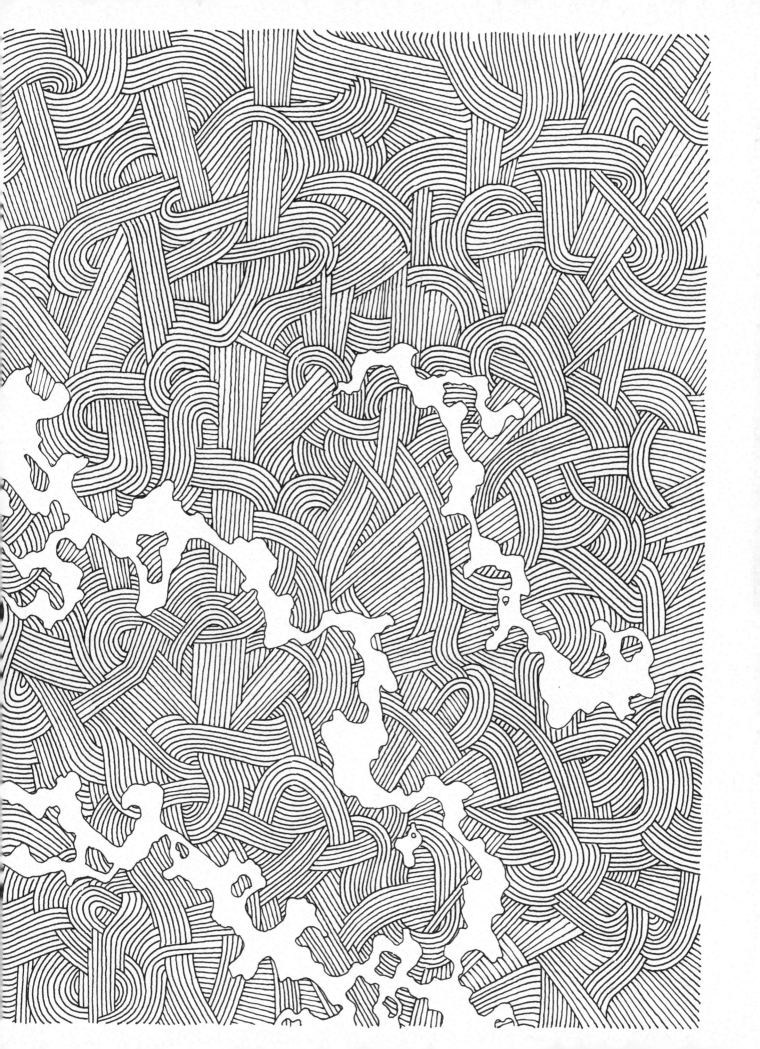

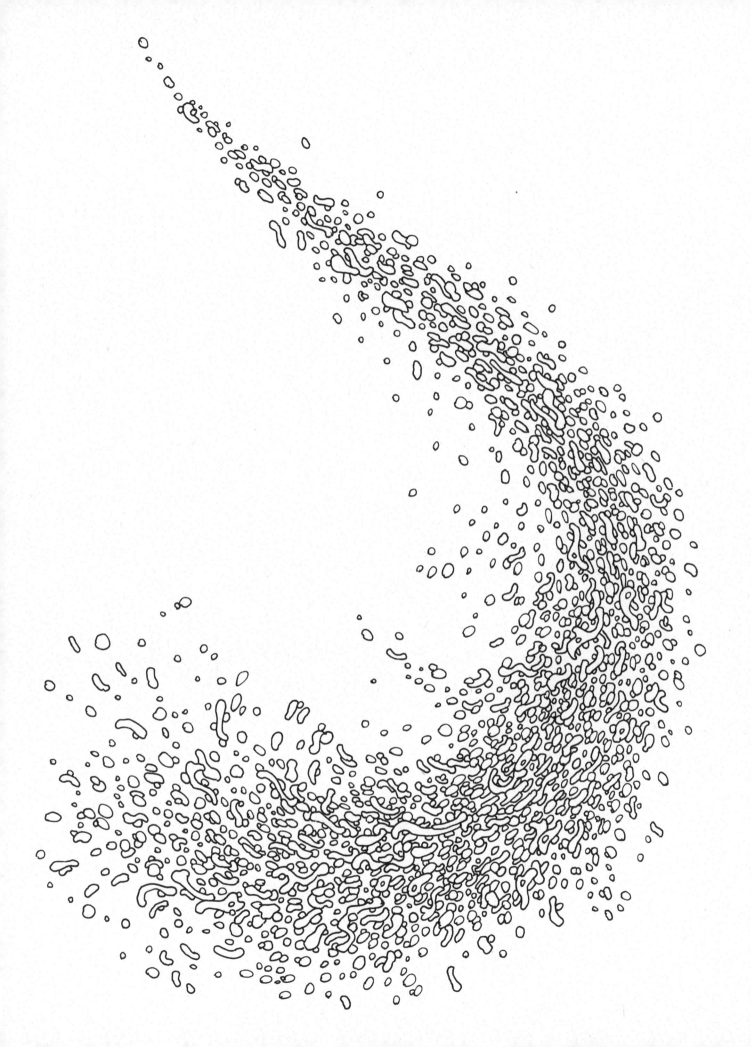

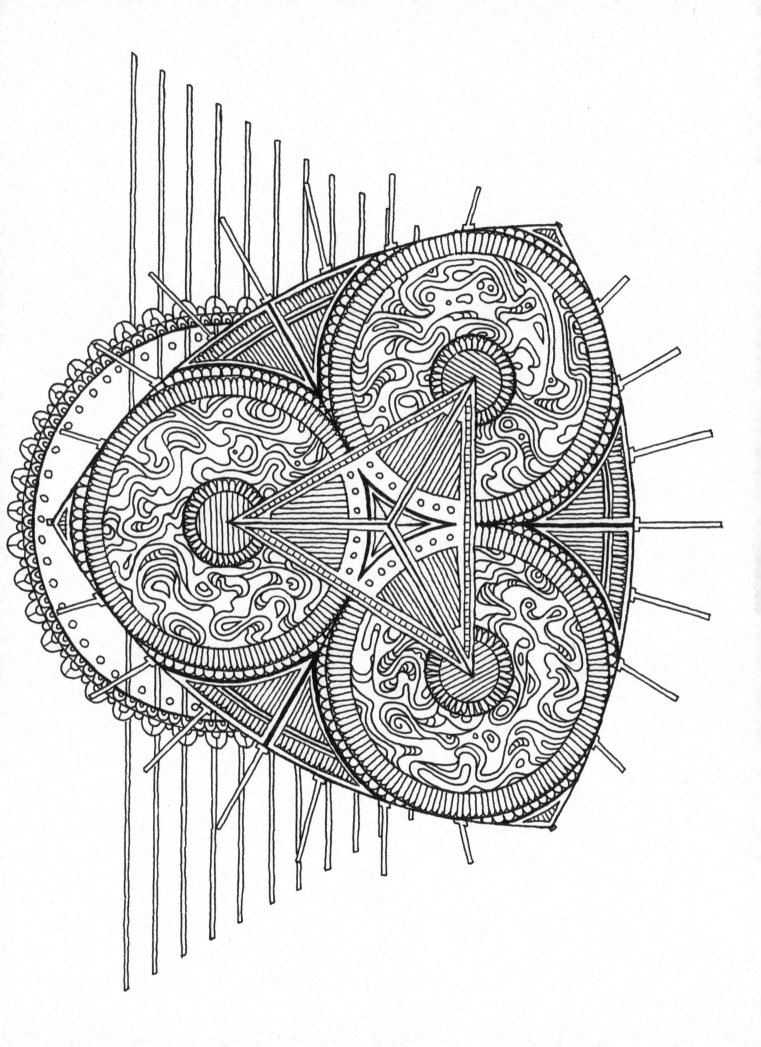

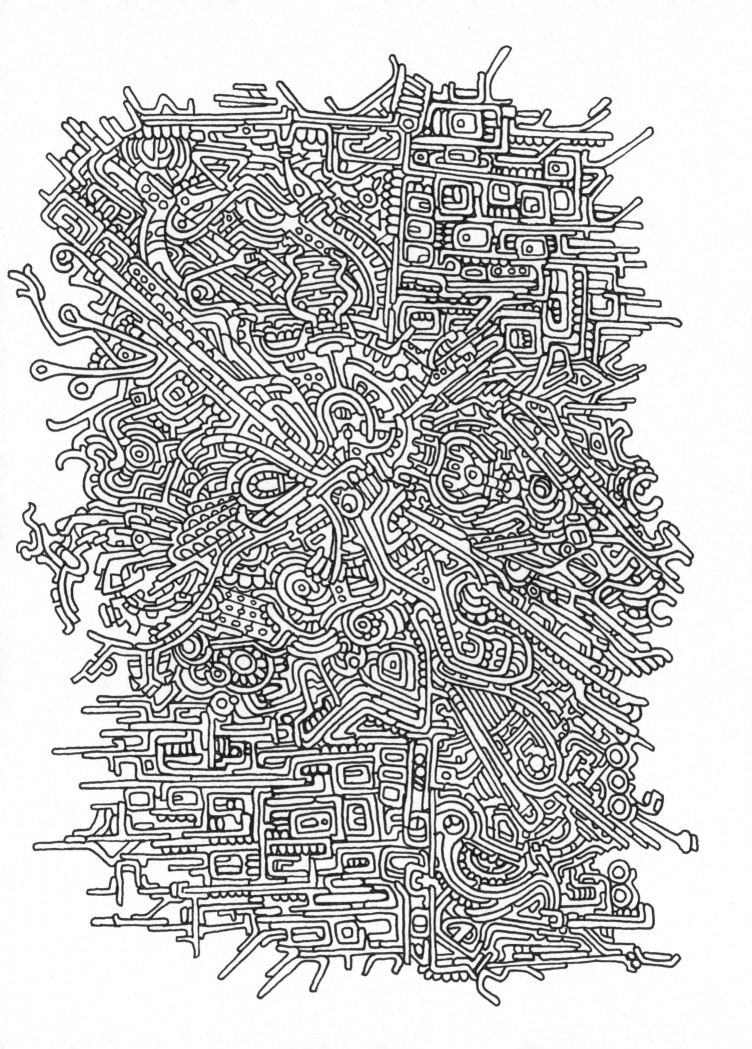